CINDERELLA

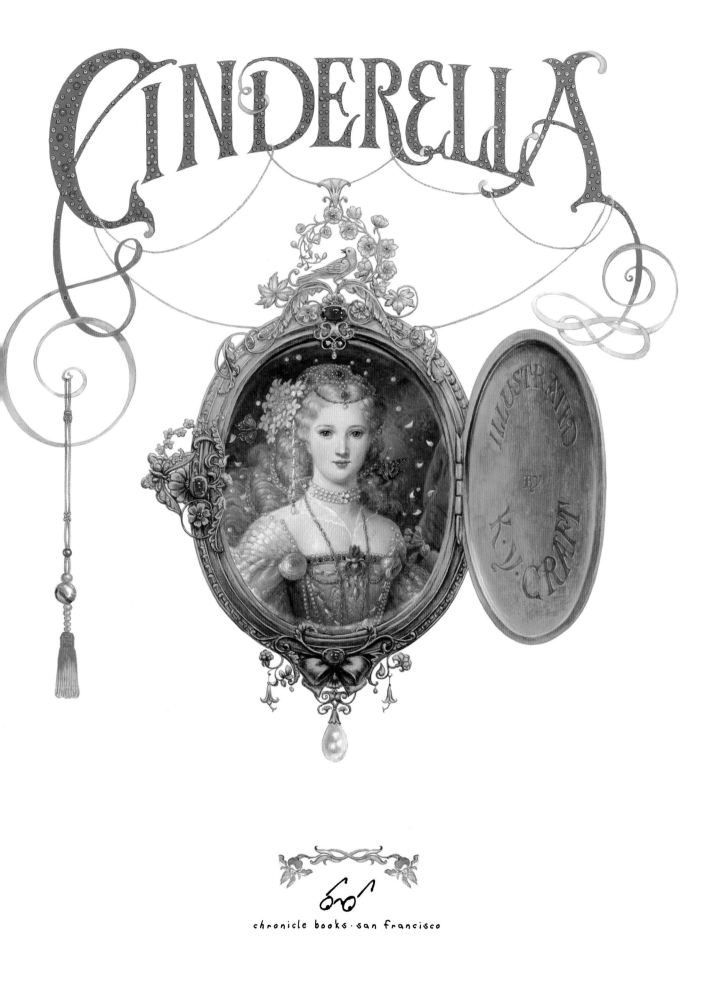

ILLUSTRATED BY K. Y. CRAFT

chronicle books · san francisco

A Note About This Book

The text for this book was adapted primarily from *The Arthur Rackham Fairy Book* and Andrew Lang's *The Blue Fairy Book*. Though Charles Perrault's 1697 version brought this story the popularity it continues to have today, other tales with similar motifs have been in existence for a thousand years. In the Grimms' "Aschenputtel," a small bird (instead of a fairy godmother) promises to grant the story's heroine her wish—an image that inspired the bird character found in this book.

The illustrations for this story depict an imaginary setting around the time of Voltaire, who lived in seventeenth- and eighteenth-century France.

The art for this book was prepared using oil over watercolor.
The text for this book is set in 17- point Adobe Koch Antiqua.
Designed by Mahlon F. Craft.
Manufactured in China.

Library of Congress Cataloging- in- Publication Data is available. A CIP catalogue record for this book is available from The British Library.

ISBN 978-1-58717-004-1

10

Chronicle Books LLC
680 Second Street
San Francisco, CA
94107

www.chroniclekids.com

FOR ALL
DREAMERS

here was once an honest gentleman who took for his second wife the proudest lady in the land. She had two equally haughty daughters, while he himself had a most kind and beautiful young girl.

Sadly, the man became ill and died not long after the wedding. Wasting no time, his wicked wife assigned his good daughter all the chores of the house. While her girls rested in lavish chambers hung with mirrors, her stepdaughter was sent to sleep on an old straw mattress in a dirty attic. And when the girl's daily work was done, she would collapse, exhausted, in the chimney corner among the cinders. "Cinderella!" her wicked stepsisters nicknamed her, but she paid no heed to their scorn.

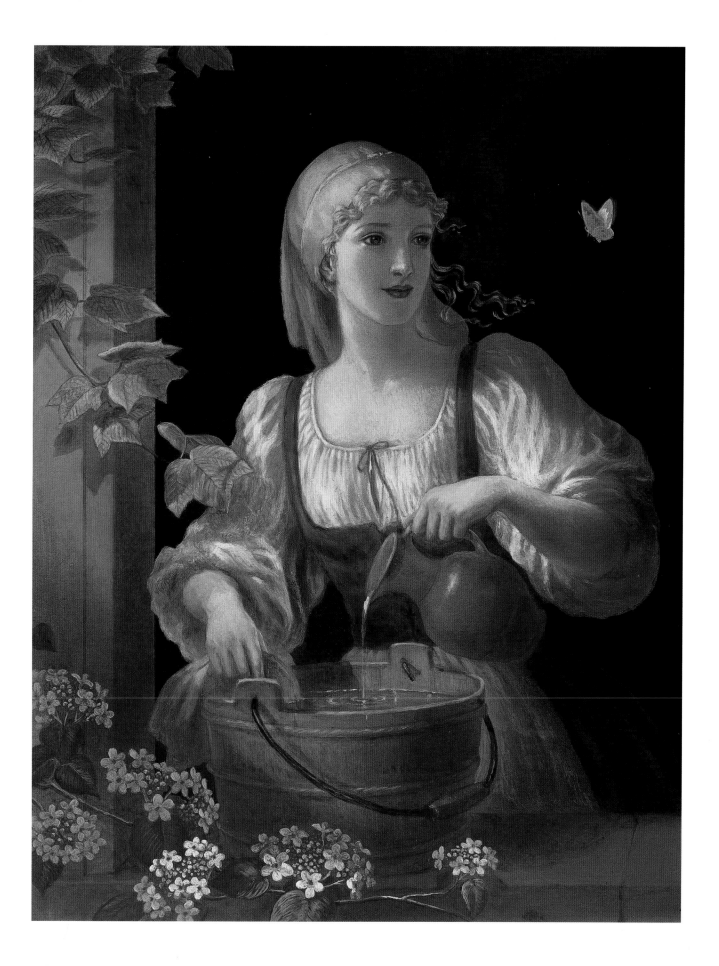

ne day Cinderella headed through a nearby wood, whistling on her way home from the town market, when her sweet melody was interrupted by the mournful chirping of a bird. Before her she saw an injured bluebird on the ground, and she knelt down, carefully examining its lame wing. But in the next instant Cinderella was startled by a man's voice calling out. Raising her head, she gasped, for heading toward her was the king's son, seated on a gallant horse. She could not imagine what a noble would ask of a girl such as her. Nevertheless, she spoke up bravely. "Have you lost your way, good sir?"

The handsome gentleman smiled at her. "Perhaps, for I wandered away from my horsemen while distracted by the sight of a fair creature."

"As was I," Cinderella replied, stroking the small animal in her hand, never imagining that he may have been speaking of her. "But the poor thing is hurt."

"I feared that you were ill when I saw your huddled figure in the distance," the prince continued. "But you are well?"

Suddenly ashamed of her humble appearance, Cinderella thanked the prince for his concern and hastily gathered her bags. "I must be home now, for the bird needs immediate attention," she explained, quickly disappearing into the woods.

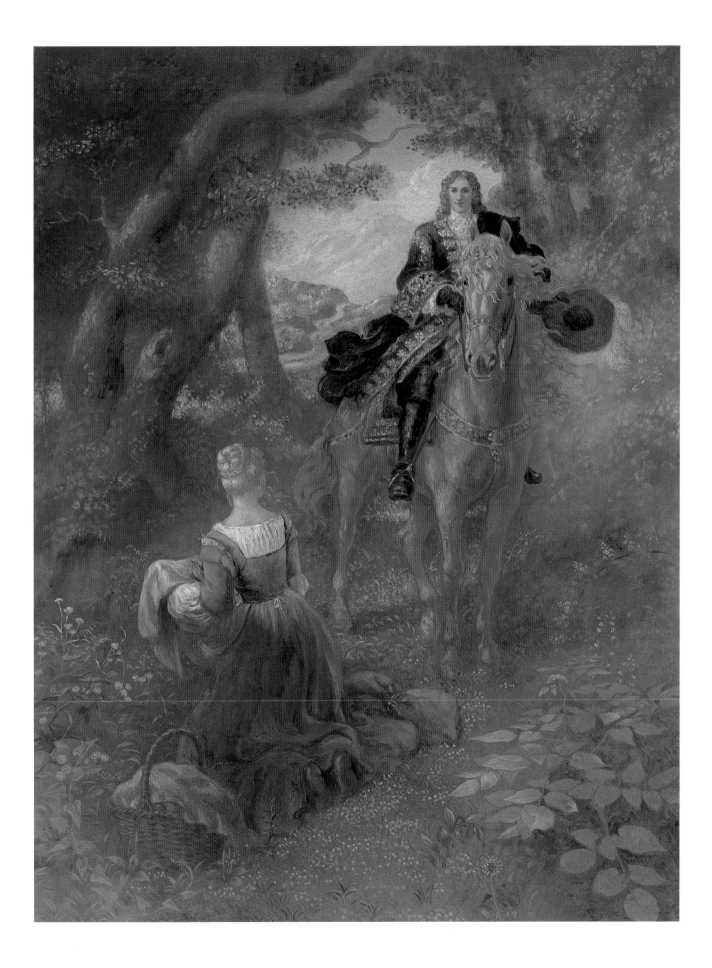

t happened that soon the king's son hosted a series of balls, and Cinderella's two stepsisters were invited to attend. They were very proud and happy, but forever fussed about what they should wear to the gala. Cinderella gave them the best advice she could, and offered to dress them and arrange their hair herself.

While she was combing out the elder's hair, the ill-natured girl said, "Cinderella, do you not wish you were going to the ball?"

"Madam," she began, for they always made her address them in this way, "you know that it is not my fortune to have any such pleasure."

"Yes, people *would* laugh to see a filthy little cinder girl at a royal ball," the sister replied. And despite those heartless words, Cinderella continued to brush her stepsister's hair until it was perfectly even and smooth. But after a coach had whisked the sisters away to the regal affair, she sat down by the kitchen fire and cried. Tonight it would be her sisters who would see the prince, not Cinderella. She had not said a word about meeting the prince in the wood, but often thought of it. In her dreams she did not rush off ashamedly, but instead rode with him to his castle, never to return to her cruel home.

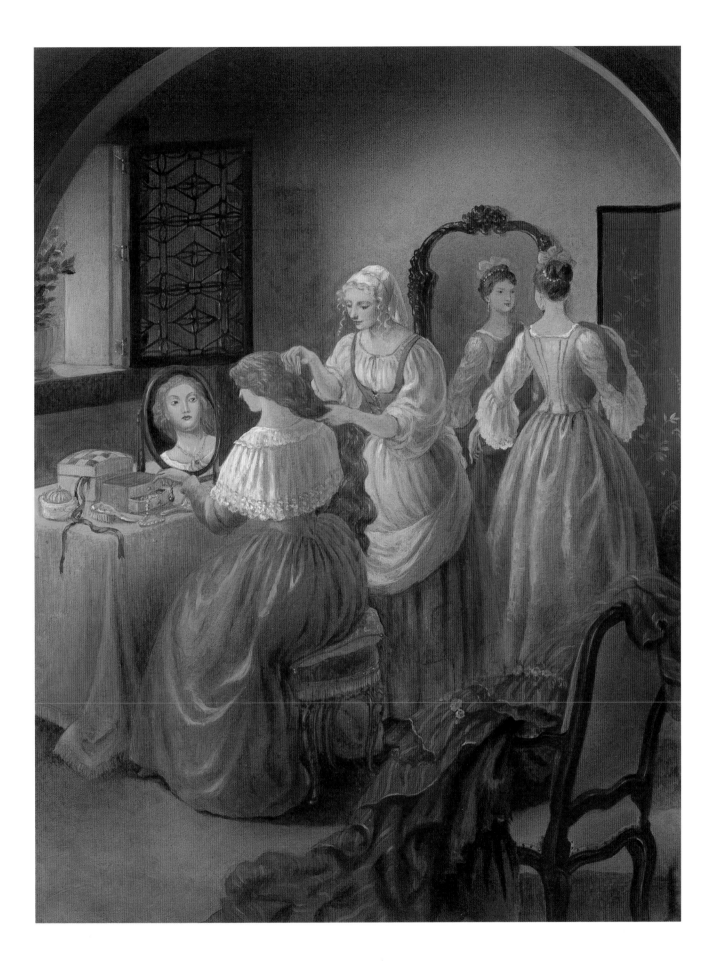

he girl's sobs quieted when she heard a bird chirping at the window ledge. "Why, you look just like a bird whose wing I nursed not long ago!" she said with wonder. And before her very eyes the bird, so small and delicate, turned into a fairy godmother.

"There's no need to cry, my dear," the woman said gently.

"Oh!" Cinderella gasped. "I . . . I . . ."

"You wish to go to the ball to see the prince, isn't it so?"

Cinderella nodded with astonishment, still unable to speak.

"Well, since you did a great kindness for me, now I shall do a kindness for you. First, run into the garden and fetch me the largest pumpkin you can find."

Cinderella did not understand how a pumpkin could help her, but neither did she understand how a bird could become a fairy godmother, so without question she obeyed.

The fairy drew out her magic wand and struck the pumpkin lightly. It blossomed into a splendid gilt coach lined with rose-pink satin. Cinderella's eyes sparkled with awe.

"Now fetch me the mousetrap out of the pantry, my dear."

Ever more excited, Cinderella rushed to bring it to her. The fairy lifted up the wire door, and as each mouse ran out she struck it and it changed into a beautiful horse.

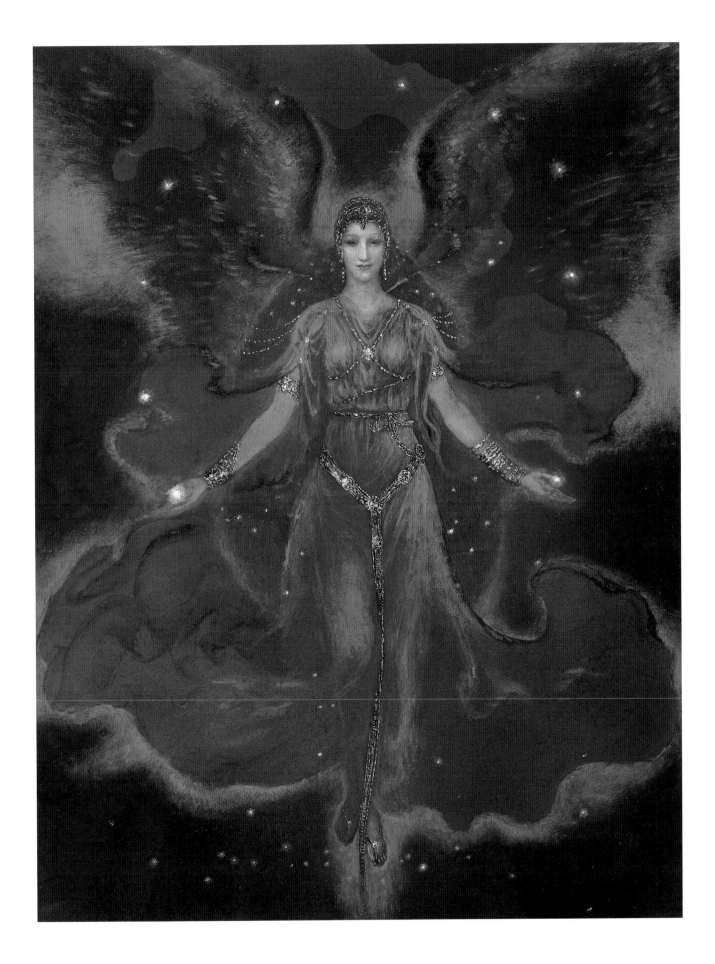

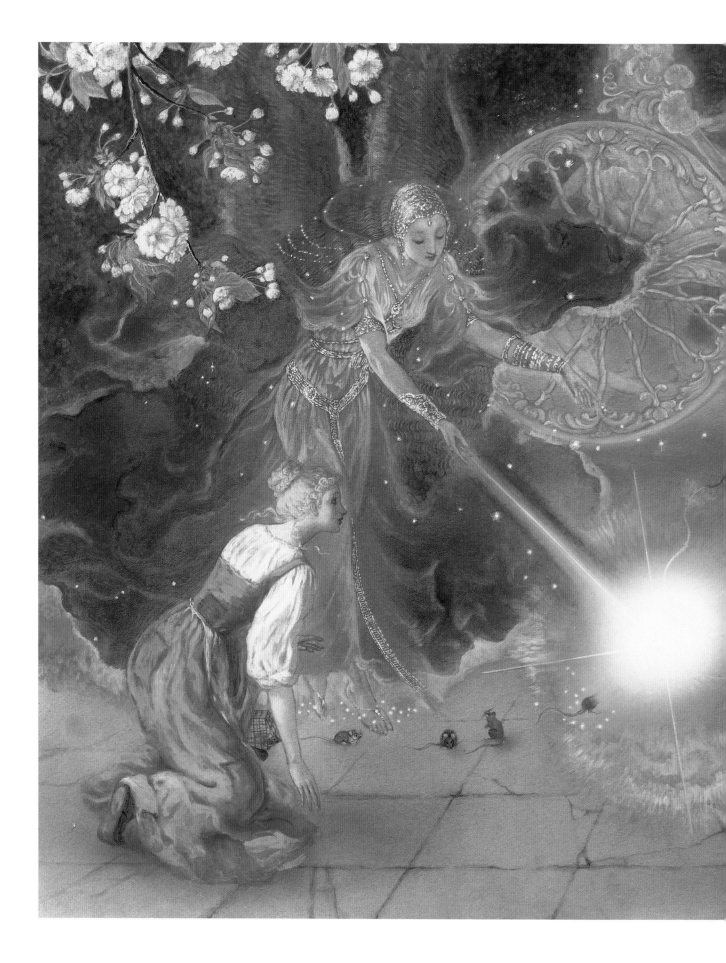

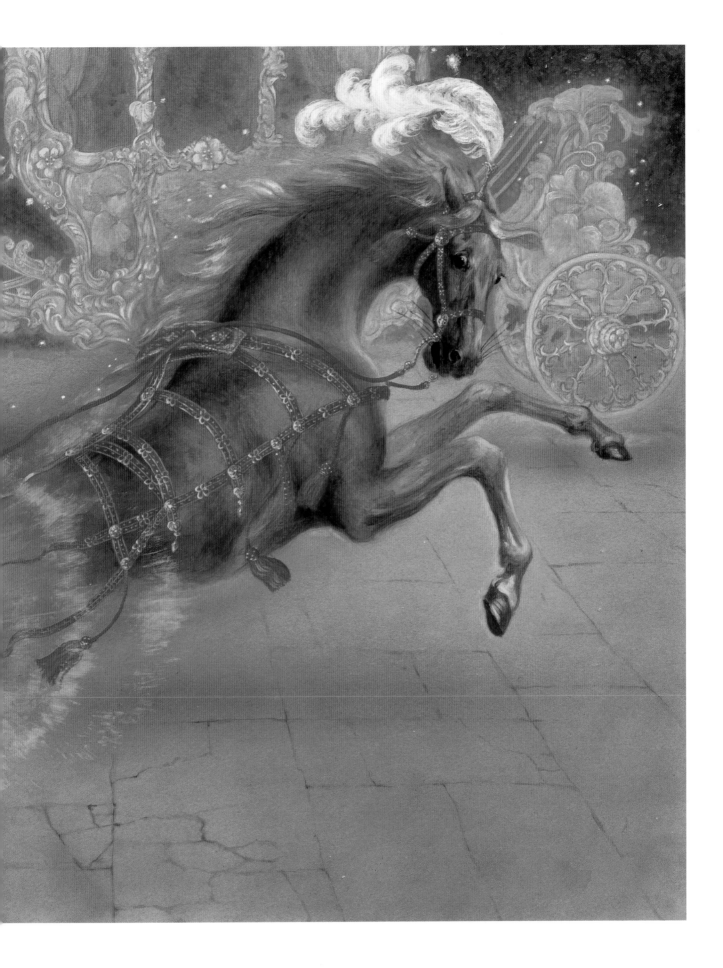

he fairy turned to her astonished godchild. "But what shall I do for your coachmen, Cinderella?"

"I saw two rats in the rat-trap," she suggested, "and they might welcome a more pleasant fate!"

"You are right. Go and look for them."

When they were found, the fairy made them into most respectable coachmen, with the finest whiskers imaginable. Afterward she took six lizards from behind the well and changed them into six footmen, all in dashing uniforms, who immediately jumped up behind the carriage, as if they had been footmen all their days.

"Well, Cinderella, now you can go to the ball," announced the fairy.

"And I shall see the prince!" the girl sang, but wilted when she looked down on her ragged frock. Before Cinderella could say a word, her godmother laughed and then touched her with the wand. Instantly her threadbare jacket became heavy with gold and jewels, and her coarsely woven petticoat lengthened into a gown of sweeping satin. From underneath peeped out her little feet, covered with silk stockings and the prettiest glass slippers in the world.

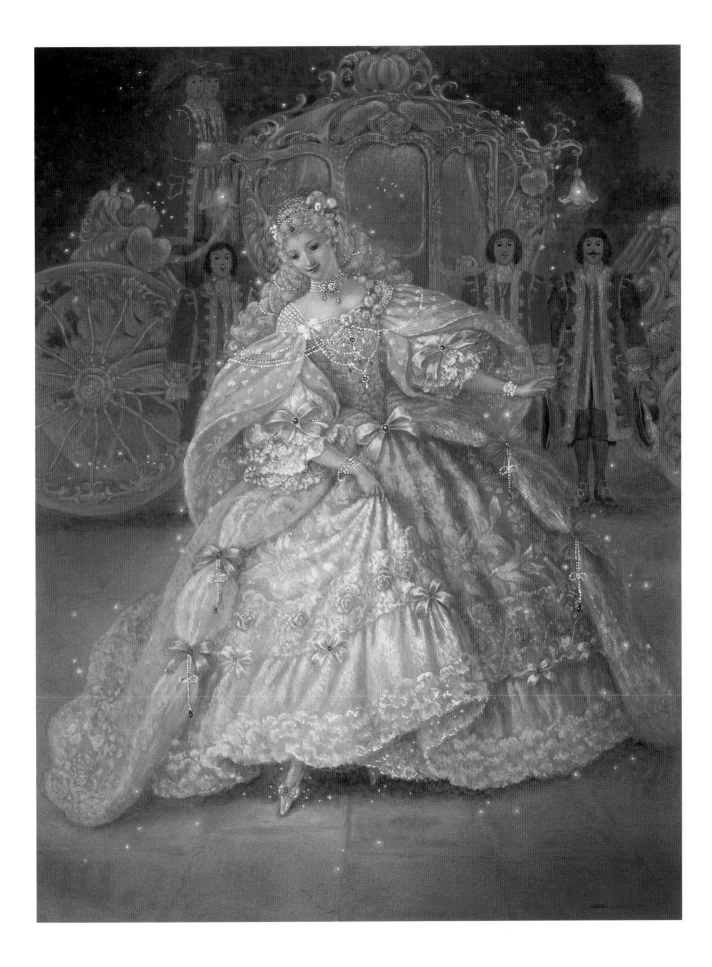

"Now, Cinderella," said the fairy godmother, "you may go, but remember, if you stay one instant after the last stroke of midnight your carriage will become a pumpkin, your coachmen rats, your horses mice, and your footmen lizards, while you yourself will appear just as humble as you did before." Radiant, Cinderella made her promise and climbed into her grand coach, which dashed off into the night.

At the palace, the prince warmly greeted his guests as they milled about the ballroom. But when Cinderella walked in, he could see no one else. The dazzled crowd stood aside to let her pass, and they whispered to one another, "Oh, how beautiful she is!" The most fashionable ladies planned to have identical garments made the very next day.

The prince offered Cinderella his hand and led her out to dance. She moved so gracefully that he admired her ever more. He thought her face familiar, but how could such an extraordinary lady exist in the kingdom without his knowledge? When he could stand it no longer he asked her if they had been introduced before.

"I'm afraid not, sir," she replied and, fearing he might remember the cinder girl in the wood, went off with a deep curtsy to seek out her sisters. She chatted cheerfully with them at supper, and they relished the attention of so magnificent a lady—for they did not recognize her in her finery.

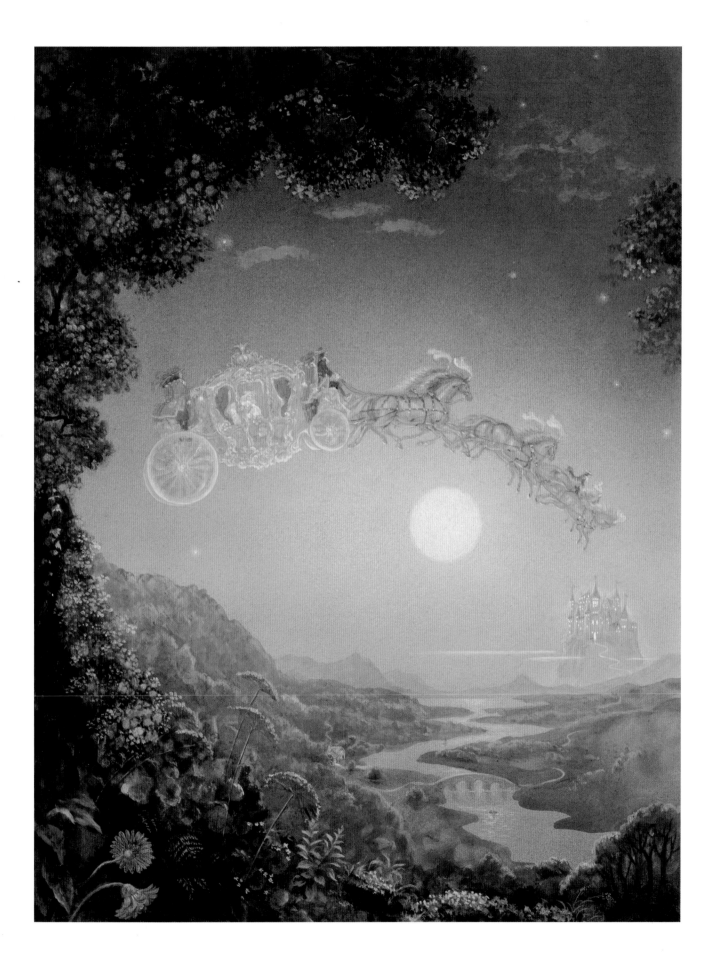

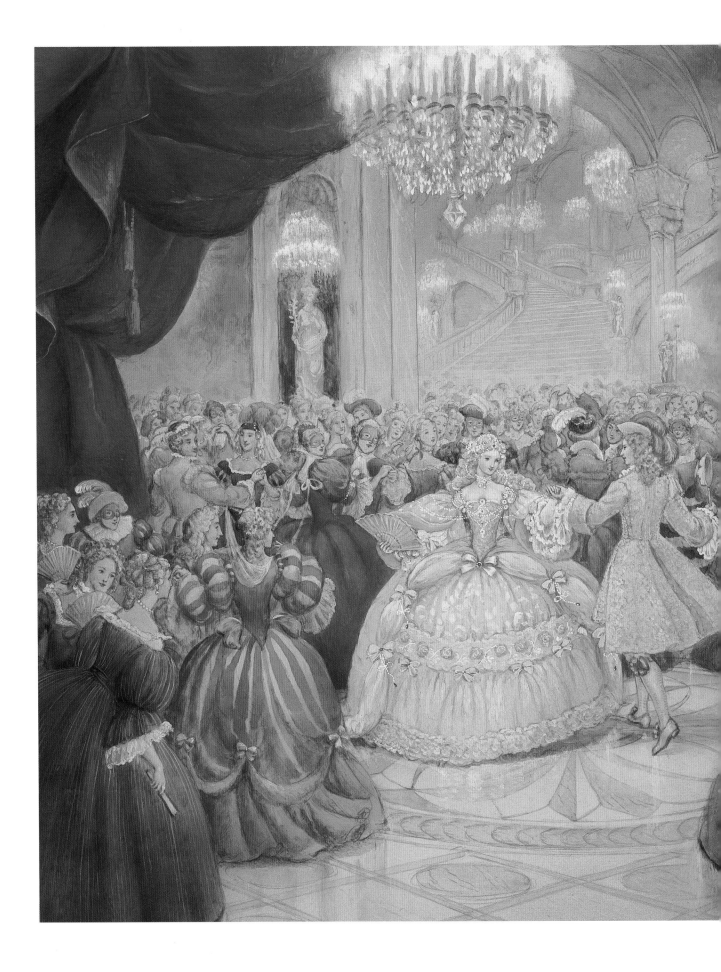

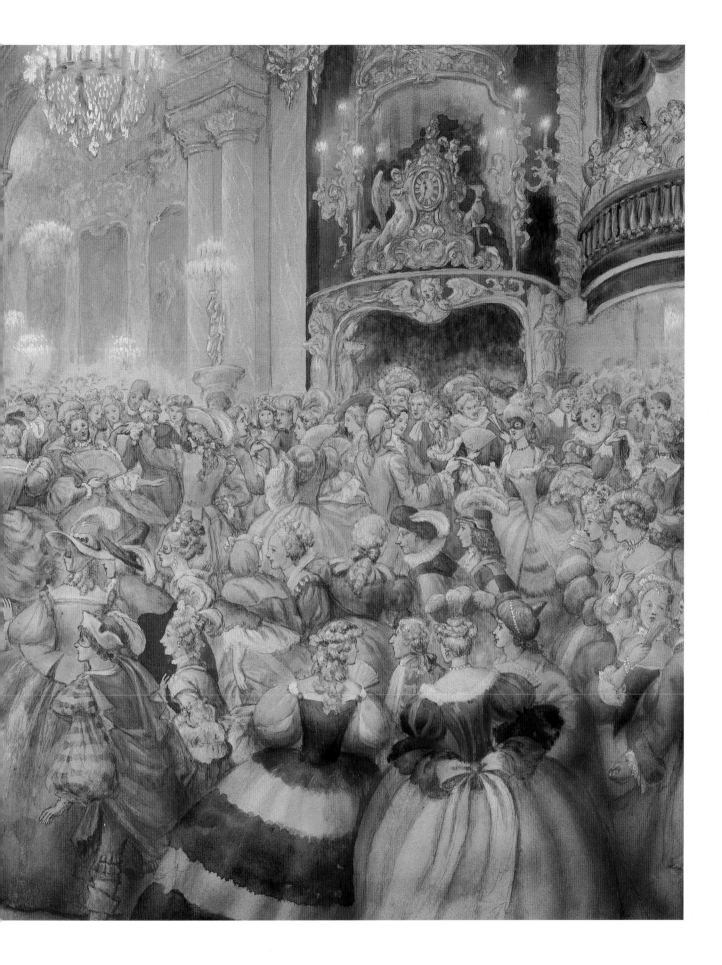

oon Cinderella heard the clock strike a quarter to twelve, and, after a gracious good-bye, she was escorted gallantly by the prince to her carriage. In no time she arrived at her own door, where her fairy godmother awaited her. Cinderella begged her permission to go to another ball the following night, and the fairy granted her approval. But when the two sisters were heard at the gate, she vanished, leaving Cinderella alone in the chimney corner.

"It was the most wonderful ball," cried the elder sister, "and there was the most beautiful princess I ever saw, who was lovely to us both."

"Was she?" said Cinderella. "And who might she be?"

"Nobody knows, though everybody is puzzling about it, especially the prince."

"Indeed!" replied Cinderella, a little more interested. "I should like to see her." Then she turned to the elder sister and said, "Madam, will you not let me go tomorrow, and lend me your yellow gown?"

"What? I am not completely *mad*!" the sister replied. "A cinder girl cannot attend such an affair, no matter what her attire."

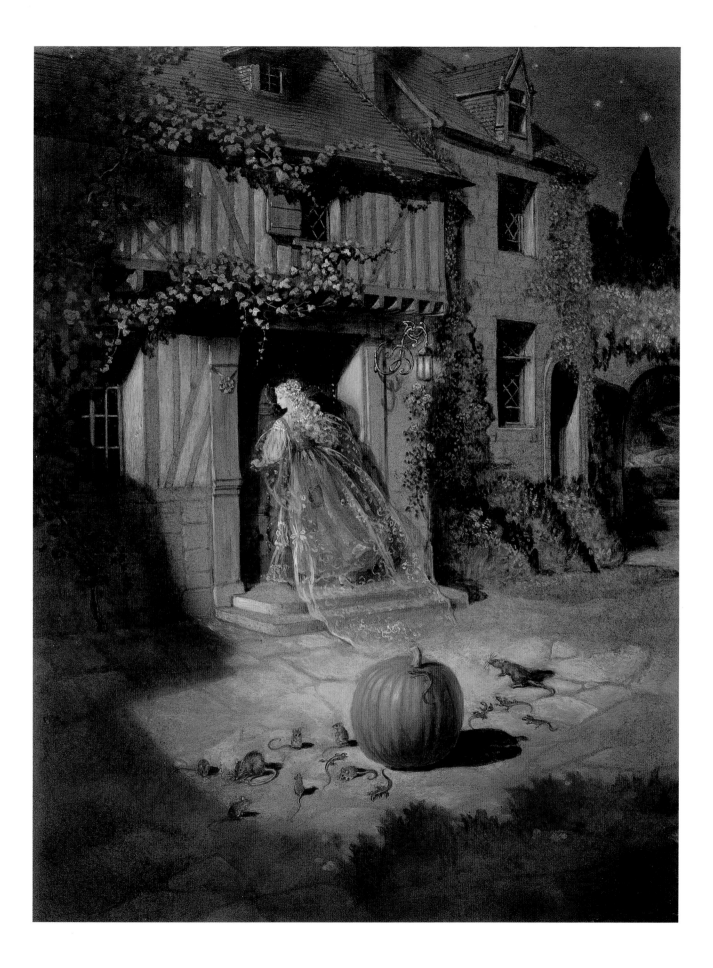

he next night came, and the two young ladies departed for the ball. Cinderella, more lavishly outfitted than ever, followed them shortly after. "Now, remember, twelve o'clock," were her godmother's parting words.

The prince's attention to her was even greater than on the first evening, and in her delight, time slipped by quickly. They were talking together near a lovely pool when he said, "Truly, my lady, I am sure we have known each other, but perhaps it is just that your face reminds me of the gentle sun and your voice reminds me of the sweet bluebird that sings at my window."

At that moment, Cinderella heard a clock strike the first stroke of twelve. Without so much as a good-bye, she leaped up with fright and fled as lightly as a deer. The prince followed, but could not catch up to the nimble maiden.

Cinderella arrived at home breathless and weary, ragged and cold, without carriage or footmen or coachmen. The only remnant of her magnificence was one of her little glass slippers; the other she had dropped on the palace stairs as she ran away.

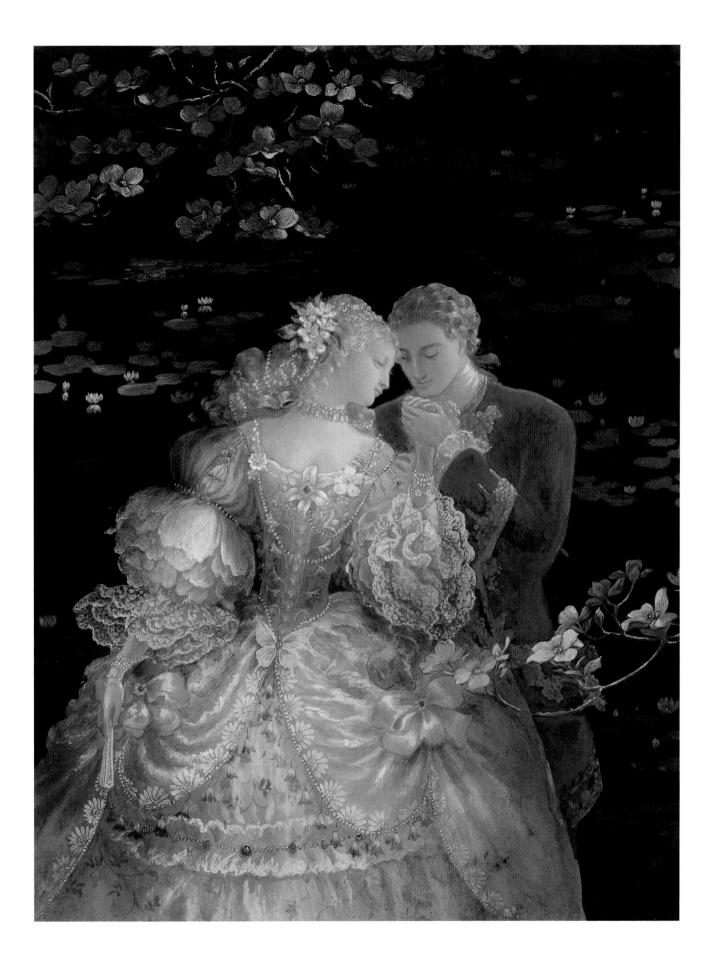

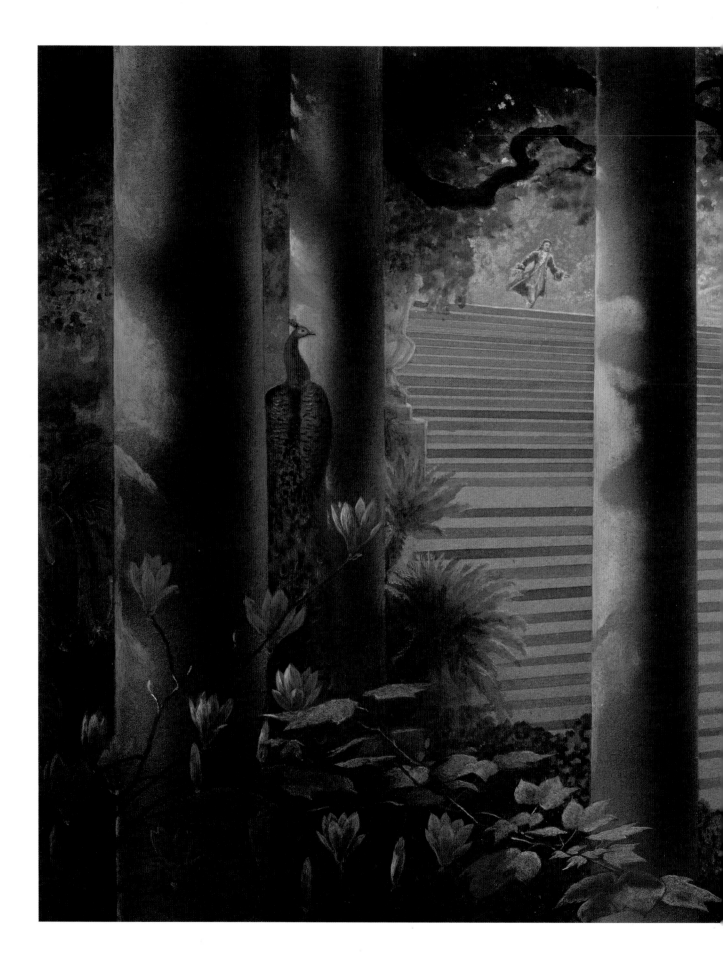

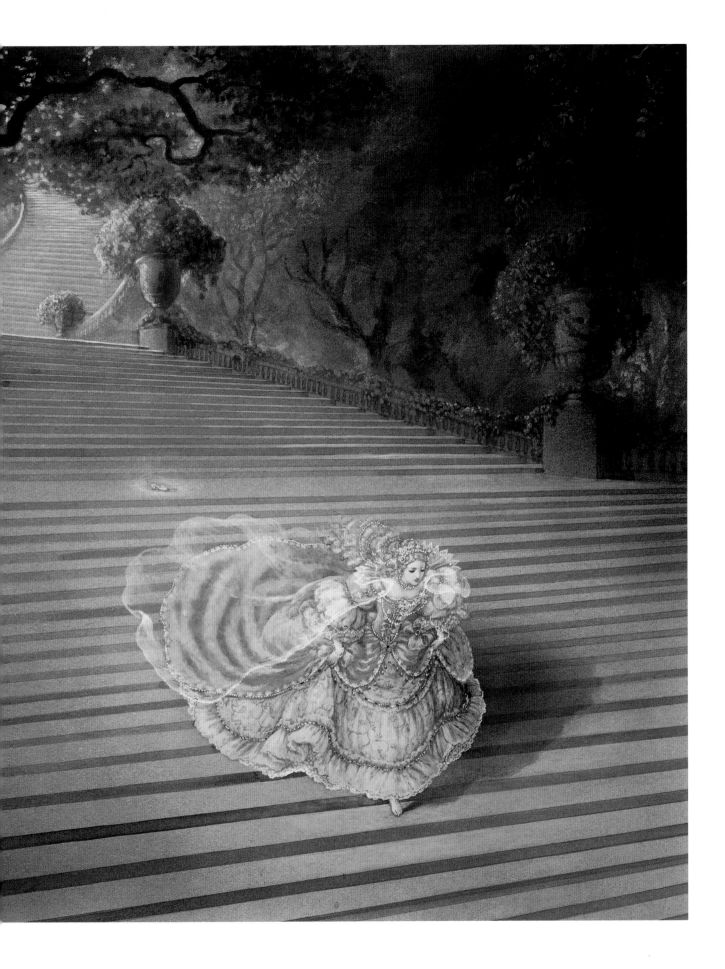

hen the two sisters returned they chattered endlessly of the enchanting princess who had suddenly fled through the ballroom and disappeared as the clock struck twelve. But the prince had found one of her little glass slippers, which he carried in his pocket and took out continually so that he might gaze at it affectionately. All the court and the royal family could see that he was desperately in love with the lady who had worn it.

As Cinderella listened in silence, her face turned rosy, but no one thought it was anything but a glow from the warmth of the kitchen fire.

The next morning Cinderella went to her weary work again, just as before. Meanwhile, the rest of the city was stunned by the sight of the prince and his page riding around town with the little glass slipper in hand. With a flourish of trumpets, a herald announced that the shoe was to be tried on the foot of every lady in the kingdom, and the prince wished to marry the lady to whom it belonged. Princesses, duchesses, countesses, and simple gentlewomen all tried it on, but it would fit absolutely no one.

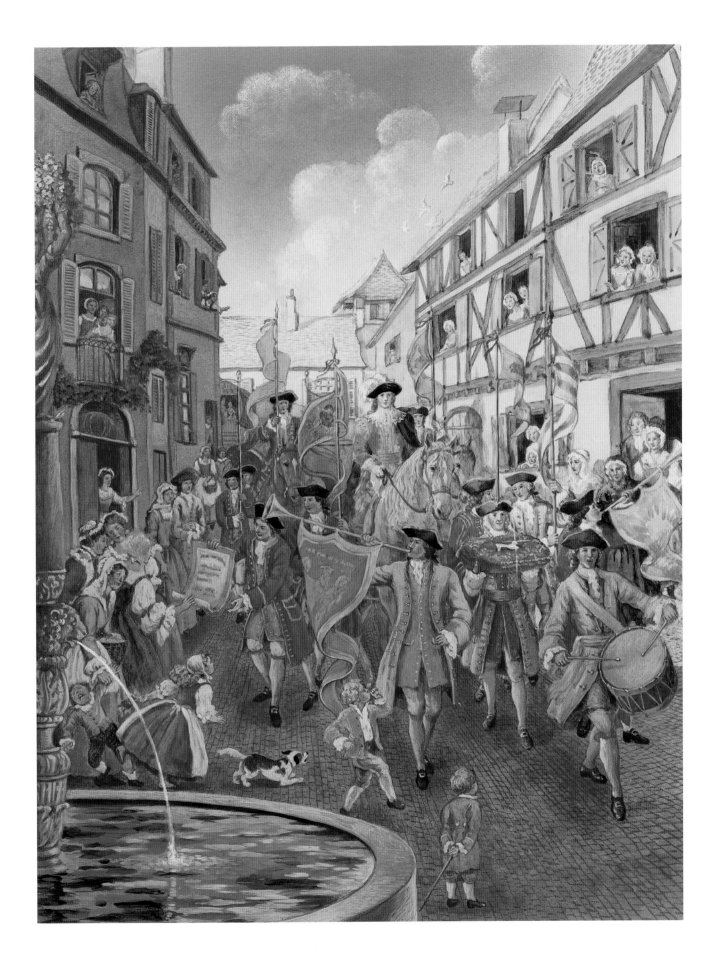

At last the prince and his assistants came to Cinderella's house. The eager stepsisters each tried to force their clumsy foot into the glass slipper, but their attempts were in vain.

"May I try it on?" asked Cinderella, who had been sitting unnoticed in the chimney corner.

"What, you?" cried the others, bursting into shouts of laughter. But Cinderella only smiled. And her sisters could not prevent her from trying on the shoe, for as she stood up, the prince recognized the girl from their chance encounter in the woods.

"Yes, perhaps this gentle lady can help me," the prince encouraged, "for my heart aches like the lame wing of the songbird she once rescued."

Cinderella's sisters looked on, horrified, as the prince himself knelt to try the slipper on her pretty little foot. It was a perfect fit. Then Cinderella drew from her pocket the matching slipper, which she also put on, and stood up. Suddenly, before them was the ravishing lady with whom the king's son had fallen in love.

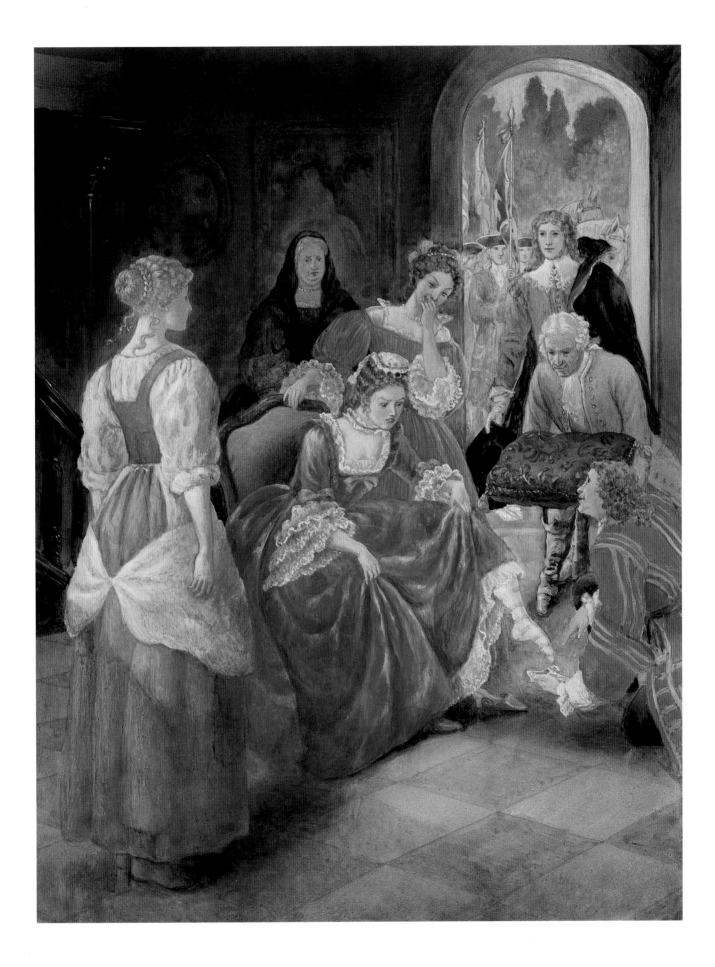

er sisters recognized her at once. With astonishment and shame, they threw themselves at her feet, begging her pardon for all their unkindness. Cinderella embraced them, telling them she forgave them with all her heart, and only hoped they would love her always and treat others with more compassion.

As for the young prince, he embraced his lost love and said, "How I knew that day in the woods that you were indeed special, but I should have fully recognized that heart whether clothed in rags or regalia." Now that he saw her soul was humble and full of goodness, he found her more lovely than ever, and he insisted upon marrying her immediately.

The wedding was a grand celebration, for all in the land were invited, whether rich or poor, beggar man or cinder girl.

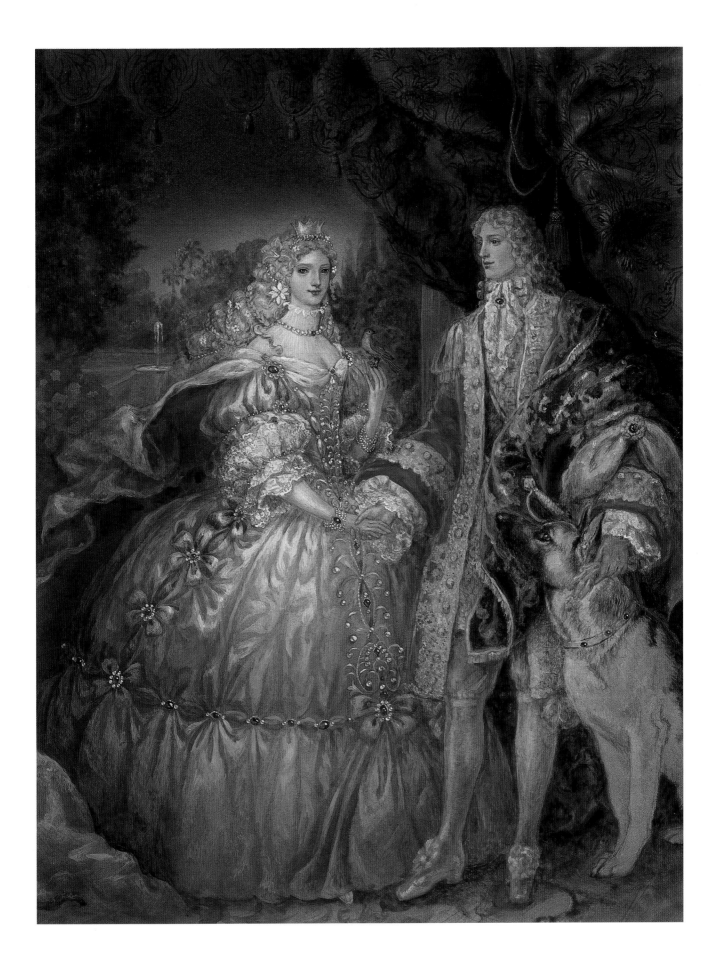

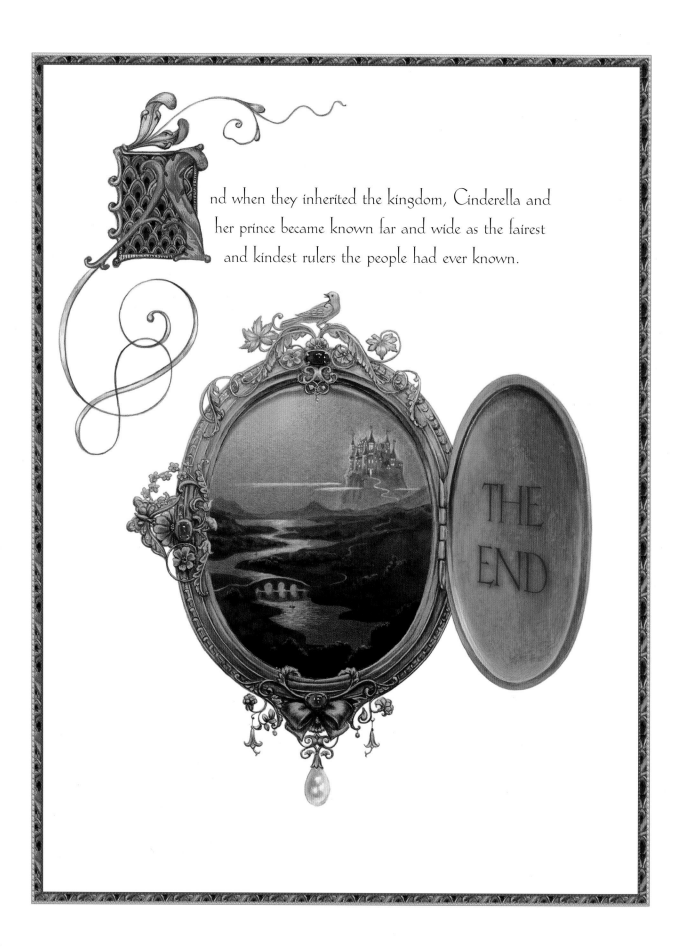

nd when they inherited the kingdom, Cinderella and
her prince became known far and wide as the fairest
and kindest rulers the people had ever known.

THE
END